CHRISTOPHER HART'S
DRAW MANGA NOW!

Shoujo Basics

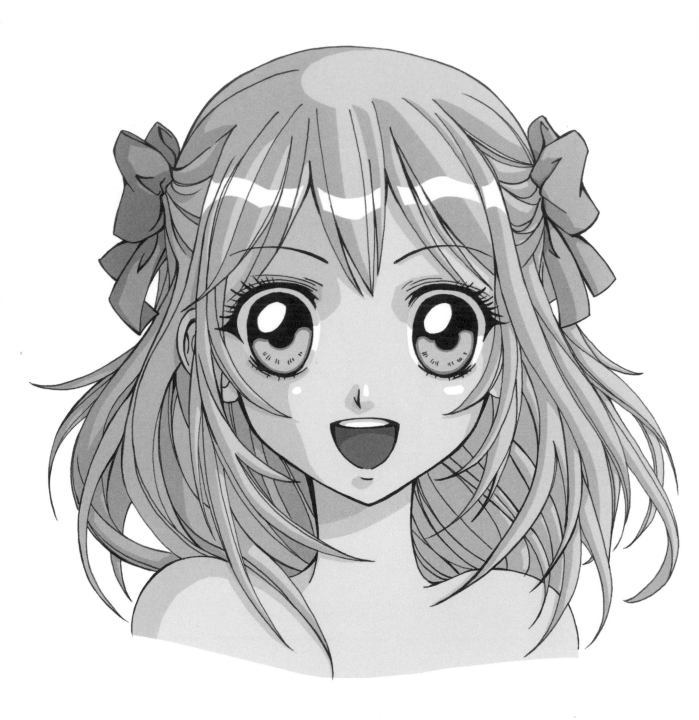

Christopher Hart's DRAW MANGA NOW!

Shoujo Basics

Christopher Hart

Watson-Guptill Publications
New York

Published in the United States by Watson-Guptill Publications, an imprint of the Crown Publishing Group, a division of Random House, Inc., New York.

www.crownpublishing.com
www.watsonguptill.com

WATSON-GUPTILL and the WG and Horse designs are trademarks of Random House, Inc.

This work is based on the following titles by Christopher Hart published by Watson-Guptill Publications, an imprint of the Crown Publishing Group, a division of Random House, Inc.: *Manga for the Beginner*, copyright © 2008 by Christopher Hart; *Manga for the Beginner Shoujo*, copyright © 2010 by Cartoon Craft LLC; and *Manga for the Beginner Kawaii*, copyright © 2012 by Cartoon Craft LLC.

Library of Congress Cataloging-in-Publication Data

Hart, Christopher, 1957-
 Shoujo basics : Christopher Hart's draw manga now! /
Christopher Hart. — First edition.
 pages cm
1. Comic books, strips, etc.—Japan—Technique. 2. Cartooning—Technique.
3. Comic strip characters. I. Title.
 NC1764.5.J3H3745 2013
 741.5′1—dc23
 2012045282
ISBN 978-0-385-34545-3
eISBN 978-0-385-34532-3

Cover and book design by Ken Crossland
Printed in the United States of America

10 9 8 7 6 5 4
First Edition

Contents

Introduction

Here's a special book for those interested in drawing the *shoujo* (pronounced show-joe) style of manga. Shoujo is the style of manga that's aimed at teenage girls but that also has garnered a strong male following. Also spelled *shojo*, it's the most popular style of manga in the known universe. This book is also particularly helpful to beginning artists, as it explains the lessons in a breezy way. It also contains lots of illustrated tips to show you how to achieve the finished drawings. I can't think of any other way to learn that's this much fun.

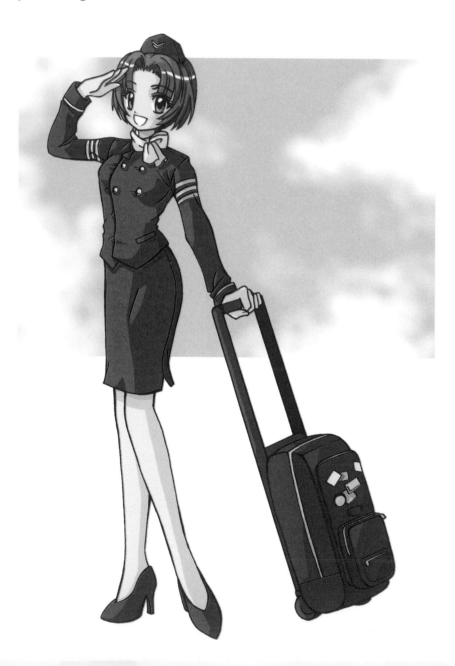

To the Reader

This book may look small, but it's jam-packed with information, artwork, and instruction to help you learn how to draw manga like a master!

We'll start off by going over some of the basic elements of shoujo. Pay close attention; the material we cover here is very important; everything builds on these basics. You might want to practice drawing some of the things in this section, like eyes, faces, and hands, on your own. I know you'll want to learn how to draw the feature that makes shoujo famous: those big, glistening eyes.

Next, it'll be time to pick up your pencil and get drawing! Using a fresh piece of paper, practice on your own, following my step-by-step drawings. When you draw the characters in this section, you'll be using everything you learned so far.

Finally, I'll put you to the test! The last section of this book features drawings that have appeared elsewhere in my book, except they'll be missing some key features. It's your job to finish these drawings, giving characters the eyes, hair, body, clothes, and facial features they need.

This book is all about learning, practicing, and, most importantly, having fun. Don't be afraid to make mistakes. If you don't make any mistakes, that means you're not attempting to tackle new techniques. In fact, the more mistakes you make, the more you're learning. Also, the examples and step-by-steps in this book are meant to be guides. Feel free to elaborate and embellish them as you wish. Before you know it, you'll be a manga artist in your own right!

Let's begin!

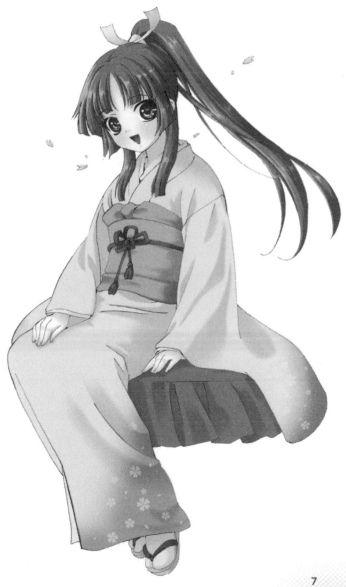

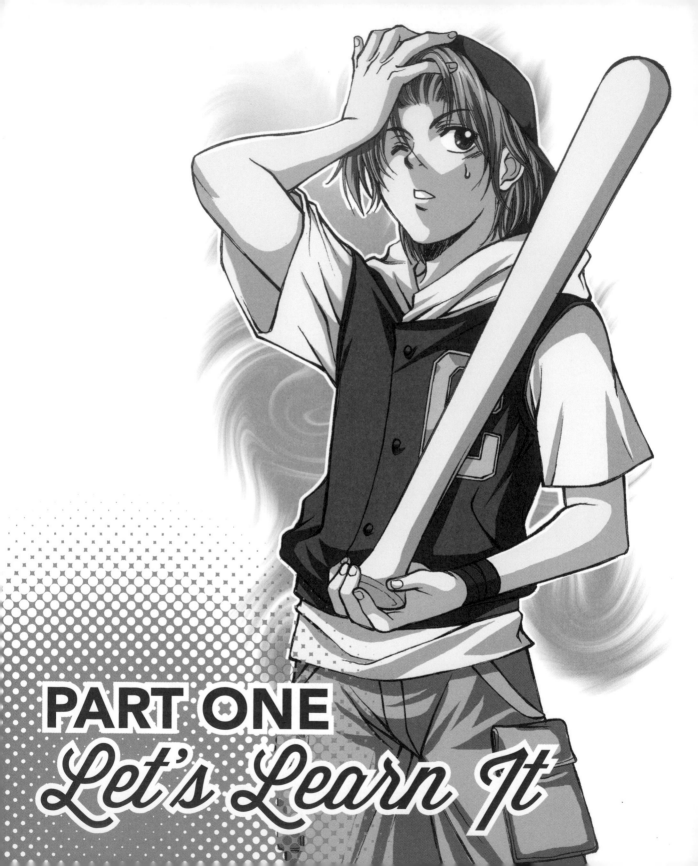

PART ONE
Let's Learn It

The Face

The shoujo look requires some very particular proportions: big, glistening eyes; a small mouth; and a tiny nose. Often, I see beginners taking great care to draw elaborate eyes. They intuitively understand what a big role this feature plays in a character's look. But what they don't always realize is that for a character to have big eyes, it also has to have a huge forehead. To counterbalance this, the character has a small mouth area. These proportions define the cute, bright-eyed look of shoujo.

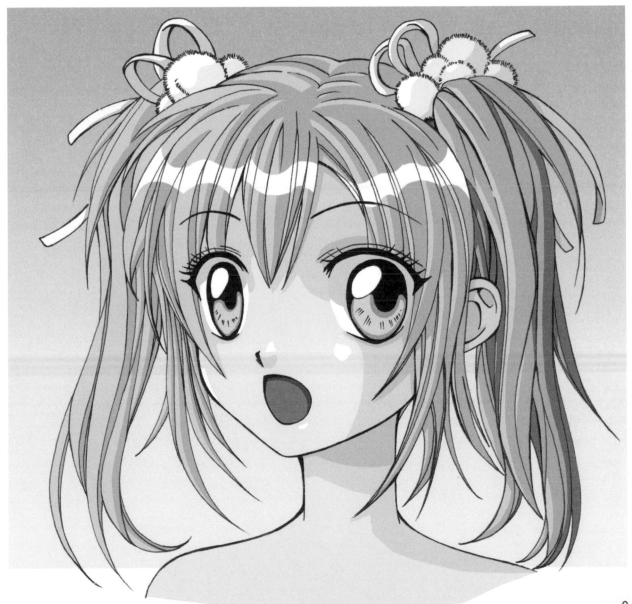

Front View

We'll start with the front view, because everything is perfectly symmetrical at this angle, and everything lines up evenly: the eyes are on the same level as each other. The same goes for the eyebrows and ears.

Notice that the eyes are left blank in the early steps. That's because you first want to focus on getting all the features in the right place before you add the details.

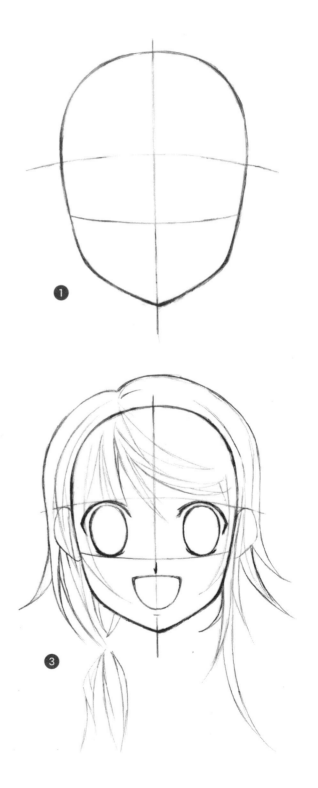

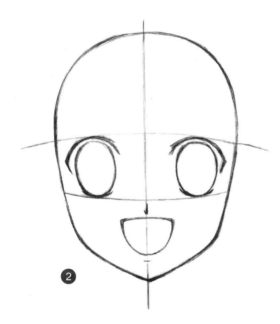

Girls

When drawing the shoujo girl's head, remember: big forehead, small mouth area. This means the head is drawn like a "square-ish" egg shape, which tapers at the bottom. Make sure that the forehead is big enough to fit in those enormous eyes. A big forehead is the typical look of shoujo characters. As a character ages, the eyes move higher up on the head, which makes the forehead look smaller.

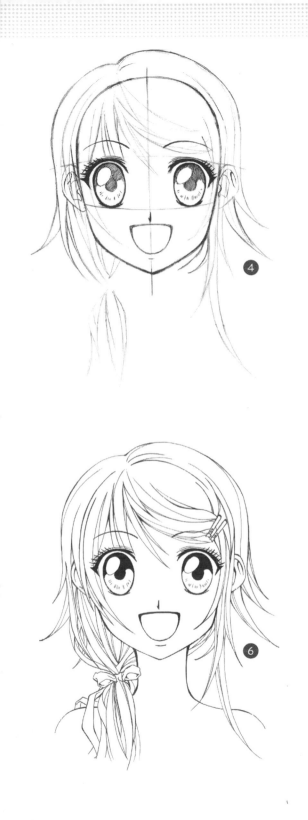

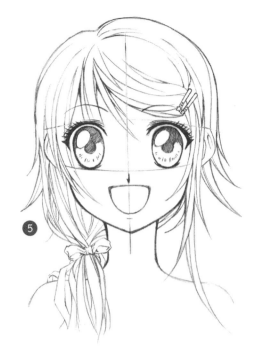

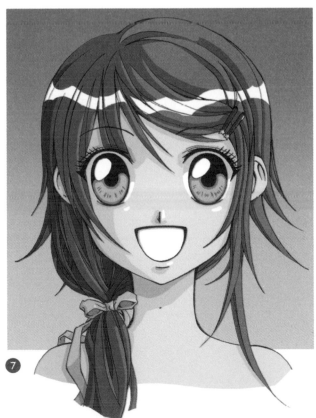

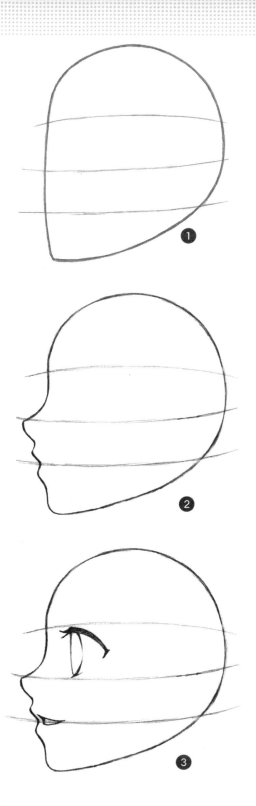

Side View

Start out with a flat front of the face. Then sculpt it to indicate the nose and mouth. The back of the head remains rounded and takes up considerable mass behind the ear.

The side view gets tricky in two places. Sometimes beginners make the eyes too small at this angle. Keep them big! Secondly, beginners can forget to make the character's lips protrude. In the side view, the lips should stick out just a touch—even on boys.

When drawing the face from this angle, think "soft curves." Don't get too pointy—unless she's an evil beauty. And never give her a thick or pronounced brow. Smooth it up.

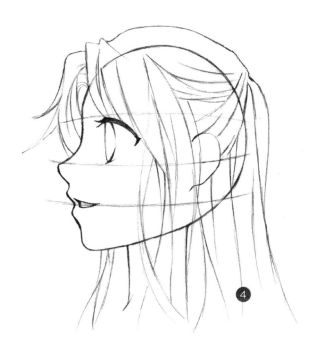

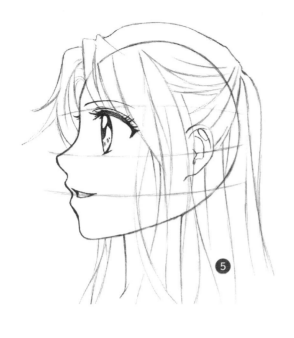

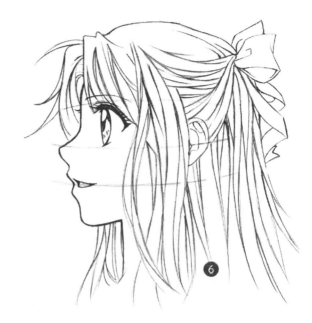

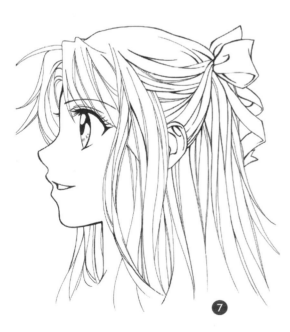

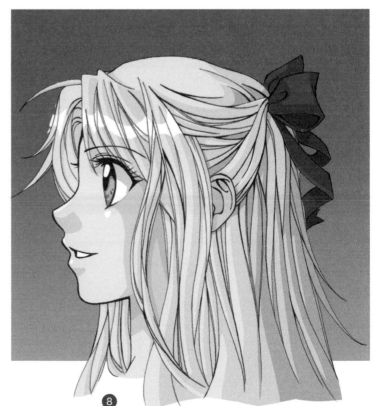

¾ View

The ¾ view is when the head is only slightly turned to one side. When drawing the ¾ view, it's important to make use of the *center line*, which divides the face vertically. In the front view, this would fall in the center, but in the ¾ view, the center line falls closer to the far side of the face and is curved to show the head's roundness. The eyes and eyebrows are no longer the same size.

And you can see only one ear. In addition, the mouth and nose have moved over toward the far side of the face.

In manga the bridge of the nose is left out regularly in the ¾ view. Noses are so petite that you can get away with using the smallest of dots to indicate only the tip of the nose.

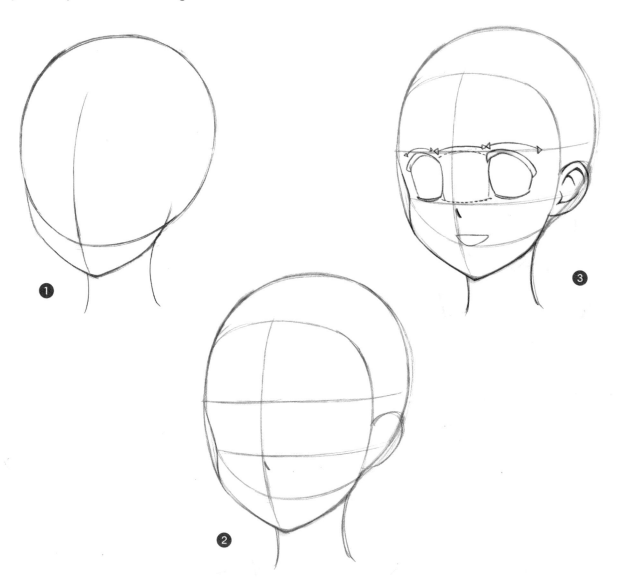

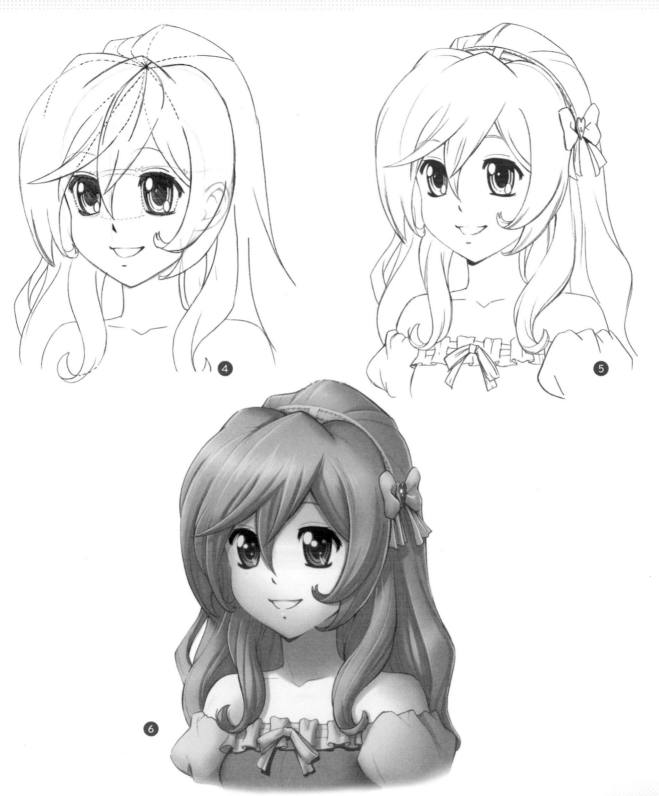

④

⑤

⑥

Boys

Male characters that are in their upper-teenage years are quite popular in shoujo. Younger teenage boys also make an appearance, but they're not quite as popular as these Romeos.

Like the shoujo girl, the teen boy's head is narrower than the girl's head. His forehead is somewhat smaller and his jawline is sleeker. Because he's a male, his eyebrows are also fuller than those of the shoujo girl, and he typically has a long, straight bridge of the nose.

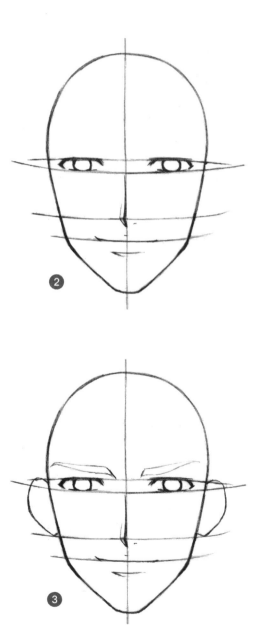

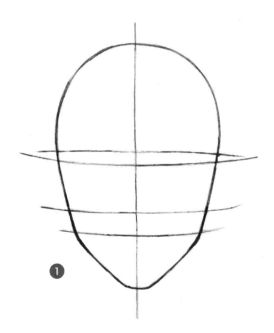

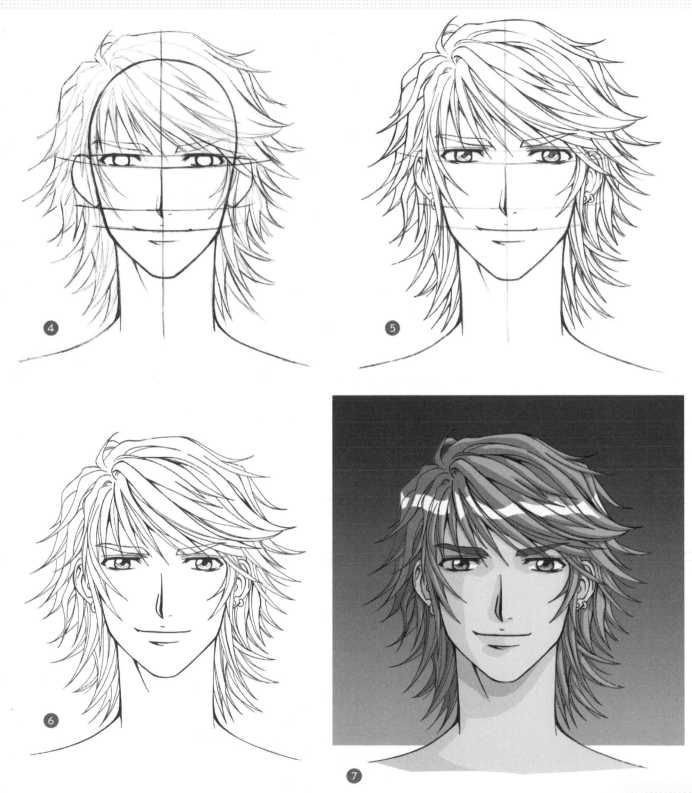

Sparkling Shoujo Eyes

I know, this is the part you've been waiting for! Nothing says *manga* so much as the eyes. They spotlight the charisma and sheer brilliance of these popular, expressive characters: The shoujo style is famous for its big-eyed personalities.

Let's start with the basics that apply to both male and female eyes: Begin with ovals for the irises (the colored part of the eyeball), not circles. Frame the eyeball with a heavy top eyelid and a thin lower eyelid. Note that the upper eyelids travel in toward the bridge of the nose, as if they're bending toward each other.

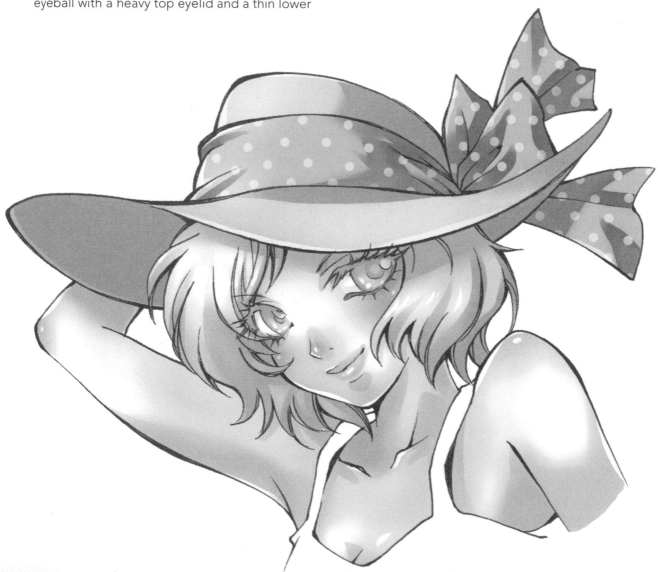

Female Eye Details

The iris in female manga eyes is larger than it is in male eyes, taking up much more of the eyeball area. As a result, the surrounding white areas are smaller. Eyelashes are more pronounced on the upper eyelid than on the lower one. The eyebrows are thin.

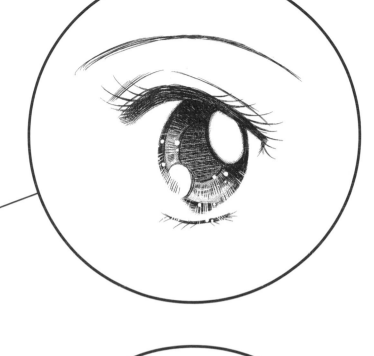

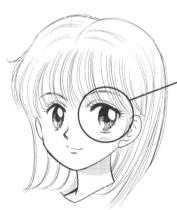

Male Eye Details

The iris in male manga eyes is smaller than it is in female eyes, taking up less of the eyeball area. So, use a smaller oval to draw it. There are no—or only the barest minimum of—eyelashes. The eyebrow, while still not too bushy, is thicker than the female eyebrow.

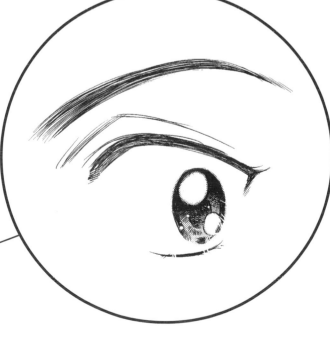

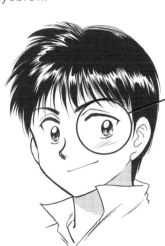

Secrets of Shoujo Eyes

Because shoujo is famous for its glamorous eyes, we'll spend a little extra time on this feature.

The top box shows how a beginner might draw manga eyes. They're quite plain and are black and white with no variation. The eyes in the bottom box are done like a professional manga artist would draw shoujo eyes: with a lighter touch and "feathered" to give a softer, glistening look. The lashes, too, are thicker and more profuse.

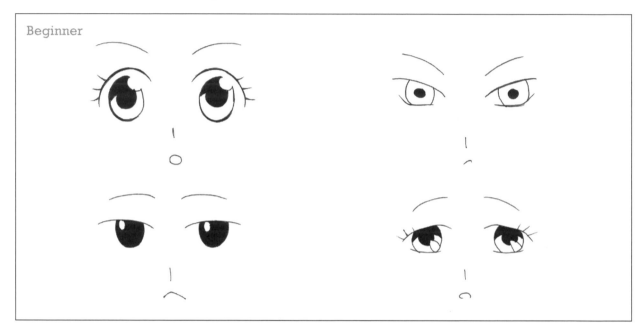

Beginner

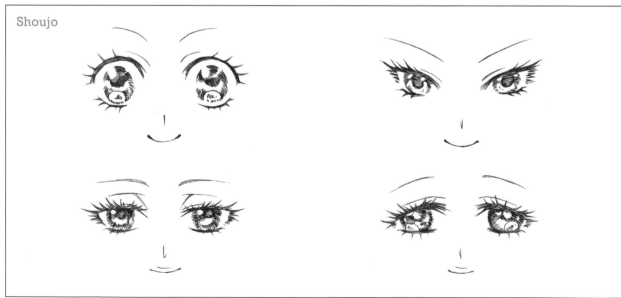

Shoujo

Gallery of Shoujo Eyes

There's no single right way to draw manga eyes. Use these examples to find the types of eyes that suit your taste. You can pick from what's here or improvise to make them your own. Some eyes will feature long lashes, some short, and some none at all. Some eyelids press down on the eyeball, and some arch above the eye, leaving a space between eyelid and eyeball. But in every case, the eye is large and round, with plenty of shines.

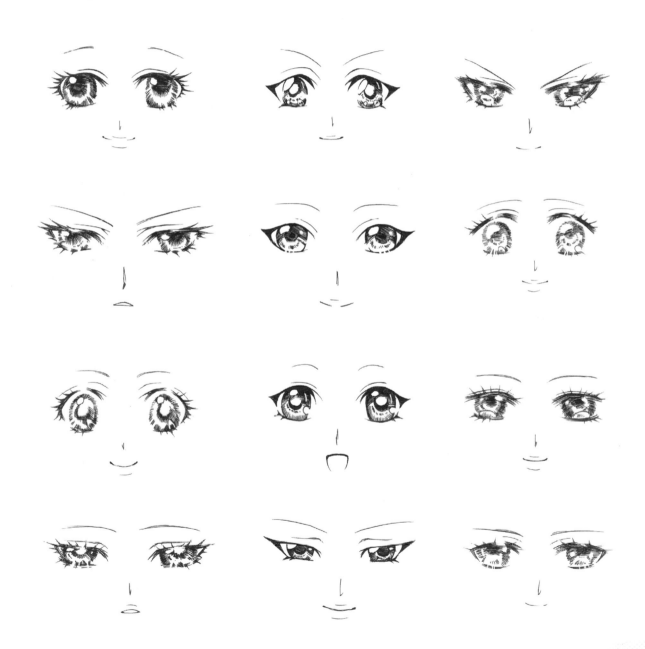

Expressions

Okay, be honest. Are you guilty of trying to create an expression using only the mouth? As you can see from these examples, the mouth is important, but the eyes are where the emotions really catch fire. Lots of expressions depend upon how high the eyelids rise above the eyes or on whether the eyelid touches, or actually crushes down on, the eyeball. And note that the *eyeball itself* changes shape and size according to the expression.

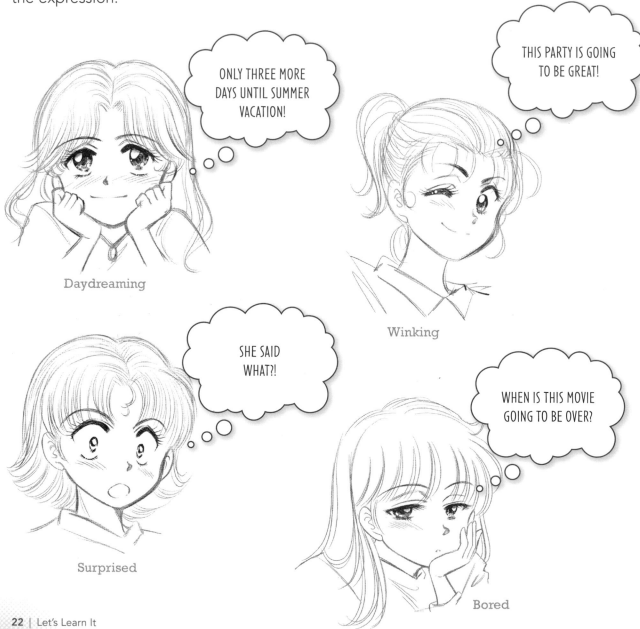

ONLY THREE MORE DAYS UNTIL SUMMER VACATION!

Daydreaming

THIS PARTY IS GOING TO BE GREAT!

Winking

SHE SAID WHAT?!

Surprised

WHEN IS THIS MOVIE GOING TO BE OVER?

Bored

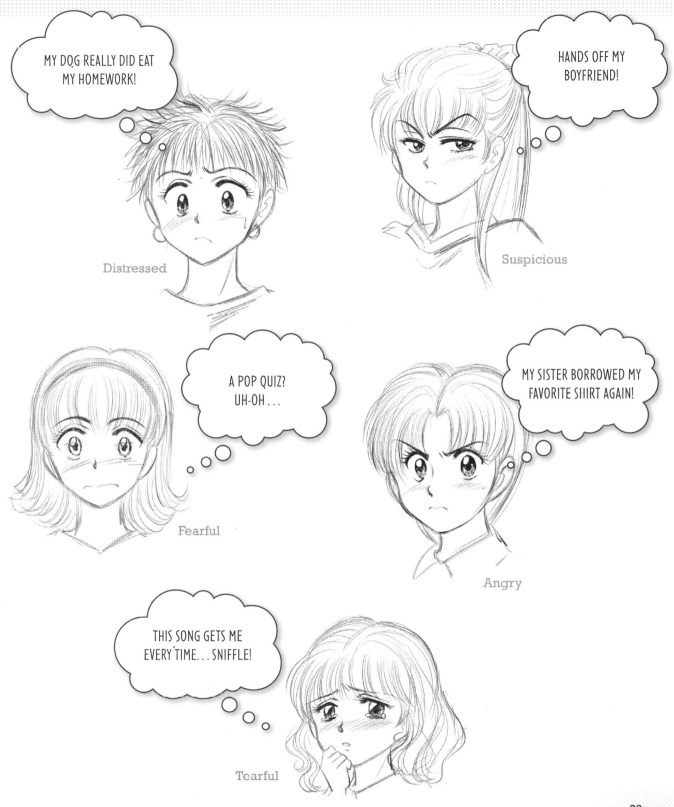

Hair

Hair is a very important feature in shoujo. It's used to add glamour, to add size to the head (and thereby increase the visual presence of the character), and to carve out a unique identity for a character whose face might otherwise look similar to others.

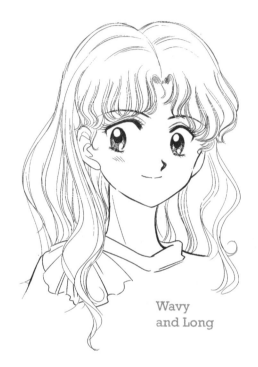

Wavy
and Long

Hairstyles for Girls

Ponytails are common on shoujo characters. They can be centered on the head or positioned slightly off center for a more casual look. Buns are also very popular, and long, wavy hair is seen on schoolgirls. Ringlets are mostly used on characters in historical genres or stories.

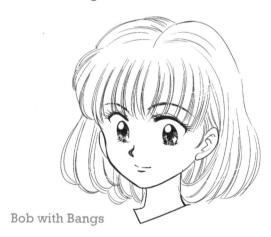

Bob with Bangs

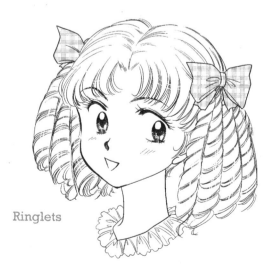

Ringlets

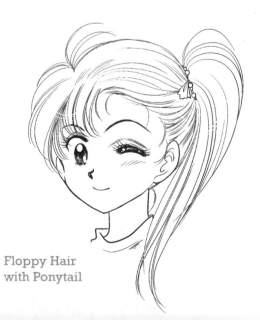

Floppy Hair
with Ponytail

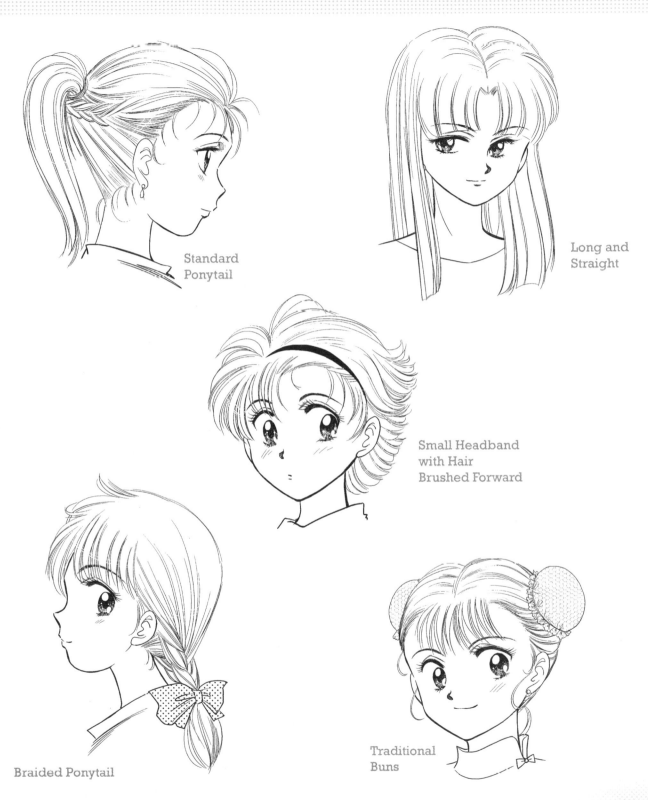

Standard
Ponytail

Long and
Straight

Small Headband
with Hair
Brushed Forward

Braided Ponytail

Traditional
Buns

Hairstyles for Boys

Unless you're drawing action characters with "samurai" or spiked hairstyles or a teen-idol type with superlong hair, boys' hairstyles are much less varied than those of girls, but are still important in creating a character's look.

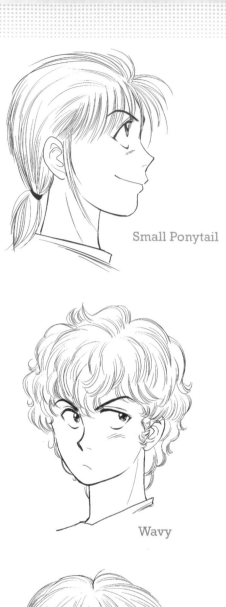

Small Ponytail

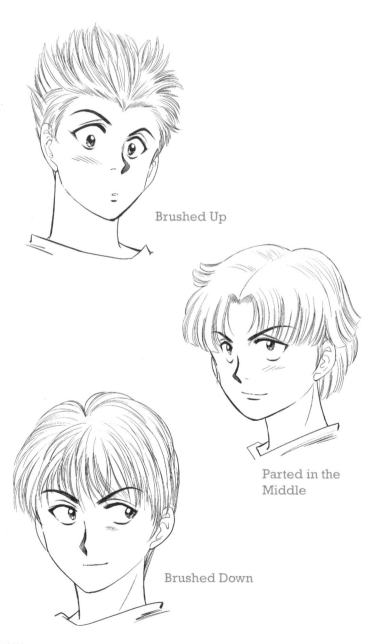

Brushed Up

Parted in the Middle

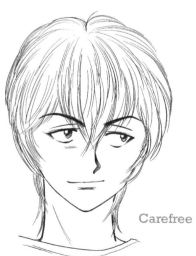

Wavy

Brushed Down

Carefree

Drawing the Body

Now we advance from drawing faces to drawing bodies. Since female characters are such a strong presence in shoujo, we're going to focus just on them in this part. You'll be able to learn how to draw boy characters' bodies in the "Let's Draw It" section later on.

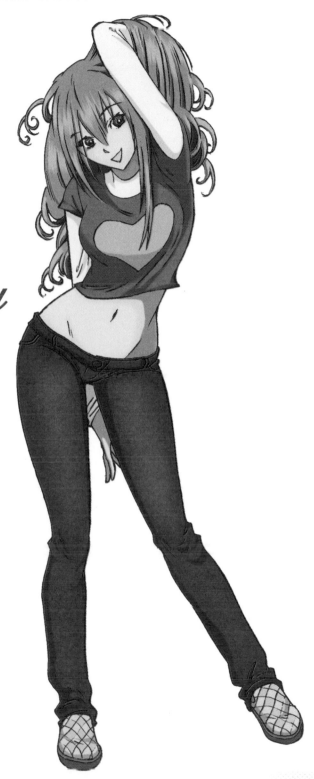

Female Body Proportions

The proportions of a character are based on its overall height. Note that the wrist and crotch appear halfway between the ankle and the head. By taking note of this halfway mark, you can prevent common errors, such as drawing the legs too long or too short. In manga, however, there's also a little room for artistic license, and often a little extra height is added to the body to achieve taller proportions.

Front View

Indicate the major joints by drawing circles on the shoulders, elbows, and knees. Why do artists typically do this? It serves to remind them that the joint is important and has its own shape.

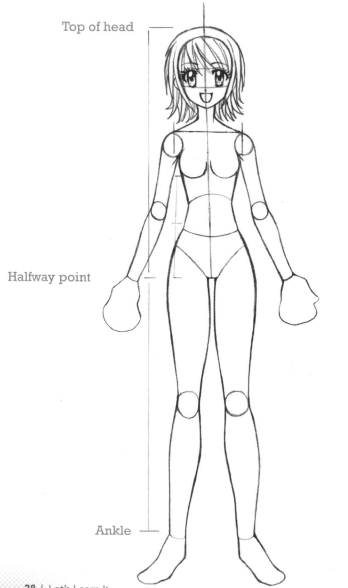

Top of head

Halfway point

Ankle

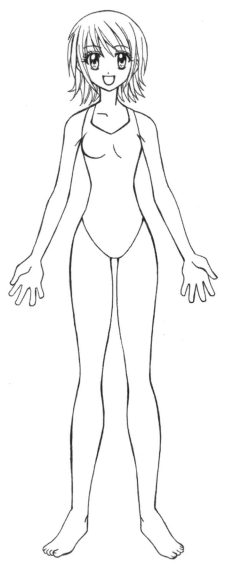

Side View

Straight lines aren't as pleasing as curved lines. Even on areas where you might assume the lines would be straight, such as the legs, they're still slightly curved. Notice the subtle rounding of the leg muscles. This principle is even more pronounced on the back, which shows a significant curve at the shoulders and, again, just above the hips. Also take note that the fingers fall at midthigh level.

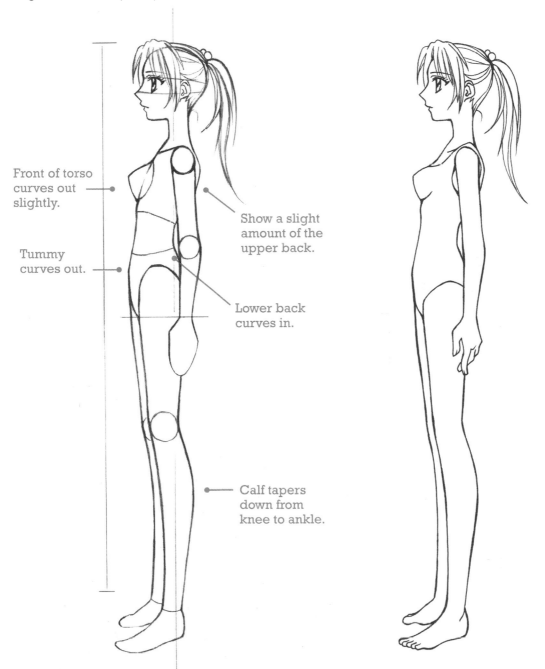

Front of torso curves out slightly.

Tummy curves out.

Show a slight amount of the upper back.

Lower back curves in.

Calf tapers down from knee to ankle.

Poses

The human body was built to move. Therefore, you've got to find a way to make your figures move in whatever pose they're in. But how do you do that? You may have heard of the *line of action.* It's a long line sketched in at the rough stage of the drawing to emphasize the fluidity of the pose. The *line of the spine* serves the same purpose.

Whichever way the spine is curving or bending is the same way the body generally moves. So use the line of the spine (indicated in red in the drawings here) to indicate this flow of action. When you sketch the line of the spine in your rough drawings, try to make it curve, and you'll avoid making a stiff drawing.

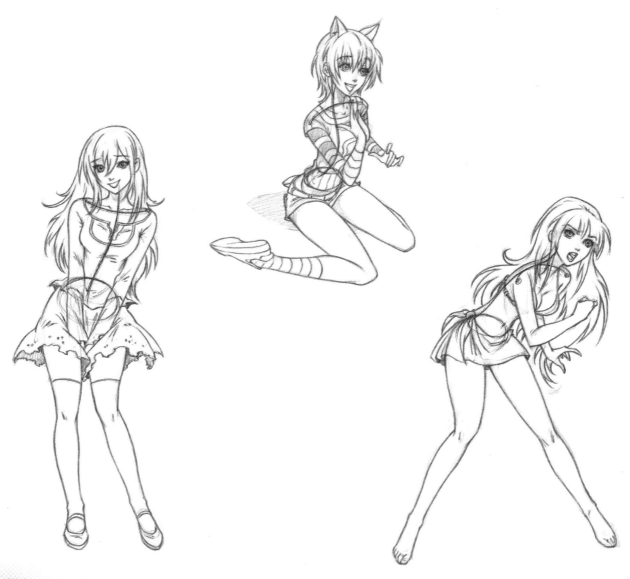

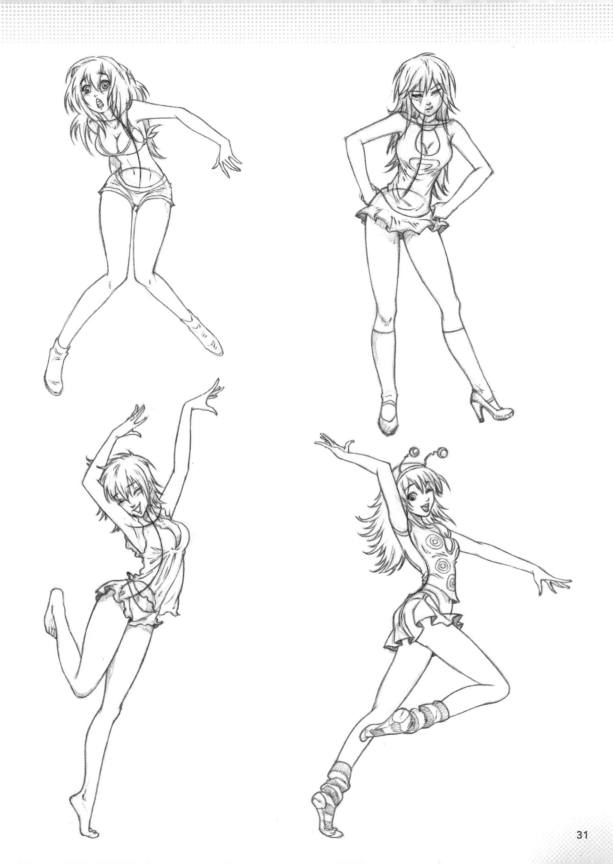

More Poses

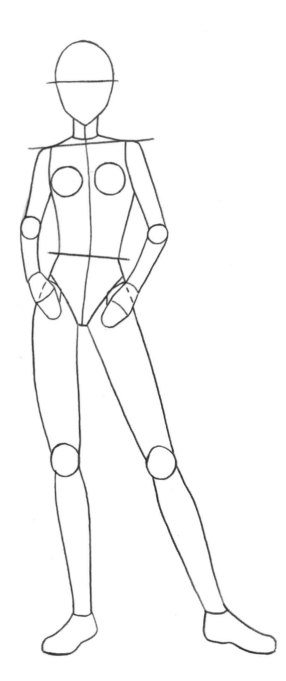

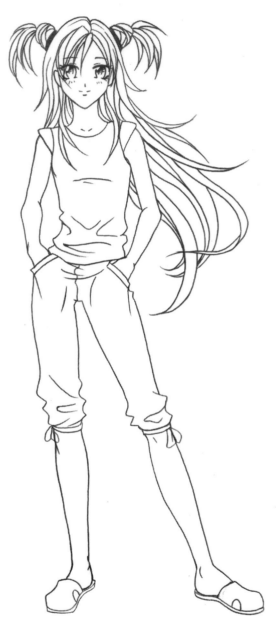

Leaning on One Foot

This pose moves the non-weight-bearing leg farther away from the weight-bearing one. This gives the pose a more stylish look. Note that the heel of the weight-bearing foot aligns with the pit of the neck to maintain balance.

One Knee Bent, Hands Behind Body

In the ¾ view, it becomes more difficult to show the tilt of the shoulders and hips. But there's an easy way to prevent the pose from appearing stiff at this angle: draw the in-and-out curves of the back.

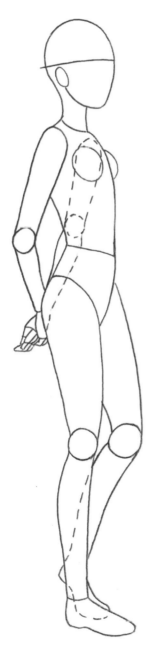

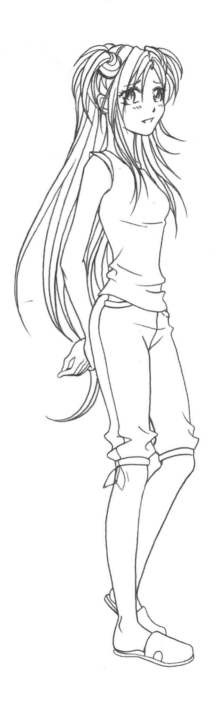

Hands in Front of Body

The locked leg is always the weight-bearing one. You can see the tension in the locked leg in the outwardly curved muscle of the thigh, which indicates that the leg is flexed.

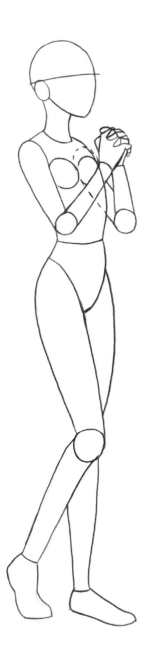

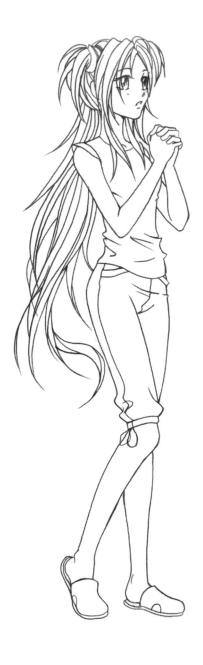

Hands

Hands can be utilitarian and simply serve a function, such as holding a pencil, or they can be expressive and convey emotion. If you're intimidated by the idea of drawing the hand, you can refer to the master diagram: your own hand! Hey, I'm not kidding—every professional artist uses his or her own hand as a model for quick reference.

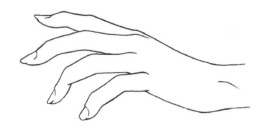

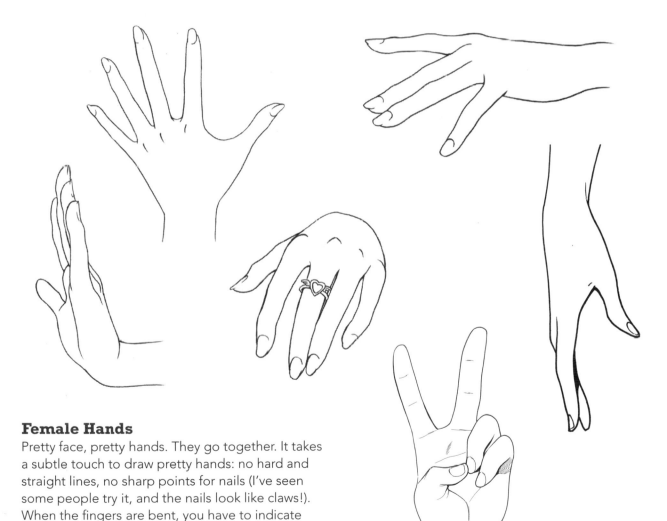

Female Hands

Pretty face, pretty hands. They go together. It takes a subtle touch to draw pretty hands: no hard and straight lines, no sharp points for nails (I've seen some people try it, and the nails look like claws!). When the fingers are bent, you have to indicate the knuckles just slightly. But, in general, feminine hands show little in the way of knuckle definition.

PART TWO
Let's Draw It

Airline Pilot

Some girls dream of jetting around the globe to exotic places. Even though an airline pilot, technically, wouldn't be a teenager, she is drawn with the features of a shoujo girl and therefore belongs in this genre. She is a *shoujo version* of a pilot who used her magical girl powers to transform into a pilot.

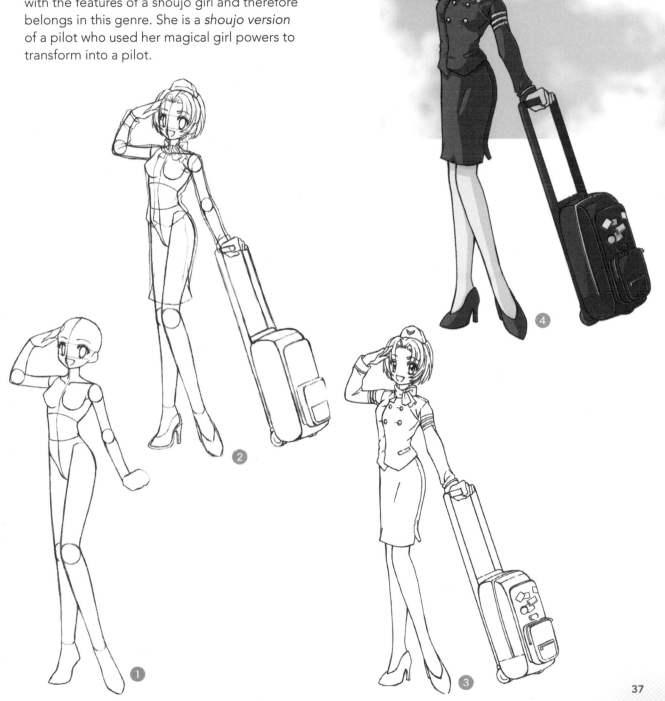

Teen Girl

Most kids and young teens have trouble standing or sitting still. They have too much energy. Try to capture this quality when drawing them, to give them a youthful appearance. Take this playful teen as an example. She's twisting her knees and feet together, pulling her arm behind her back, and pushing out her tummy, all in an effort just to stand in one place.

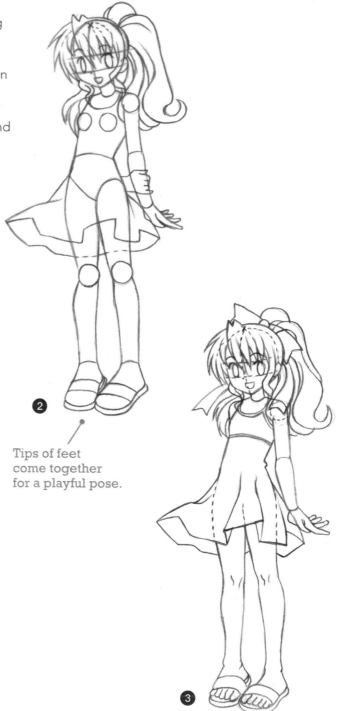

Tips of feet come together for a playful pose.

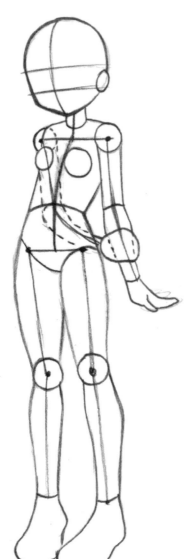

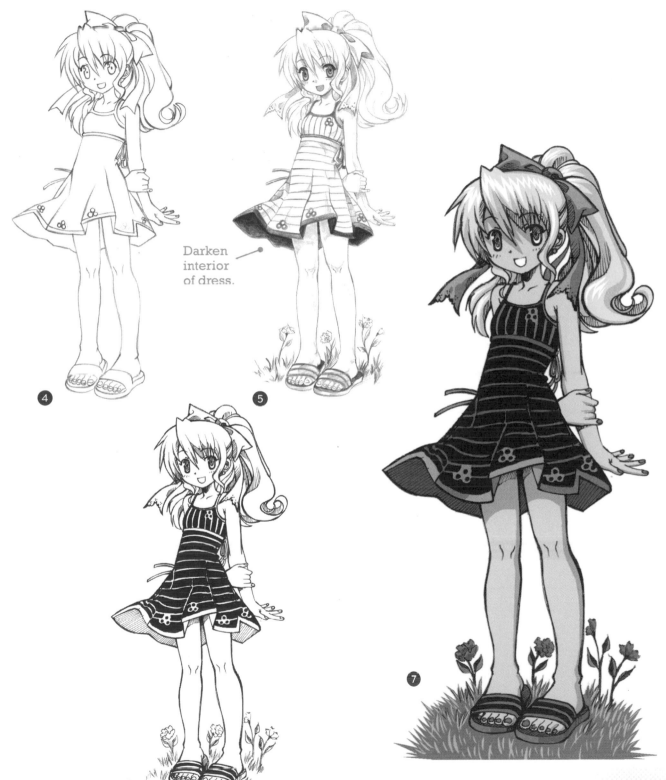

Darken
interior
of dress.

④

⑤

⑥

⑦

Tennis Player

With the soaring popularity of the manga graphic novel *The Prince of Tennis,* racket sports have gained tremendous appeal among manga fans. But *The Prince of Tennis* stars a male tennis player, so it's only natural to start introducing female shoujo tennis stars into manga. Maybe you'll be the one to invent the next great manga tennis graphic novel, which will star a *female* champion. In this humorous scene, the player's eyes are good at following the ball, but her racket . . . well, that's another story.

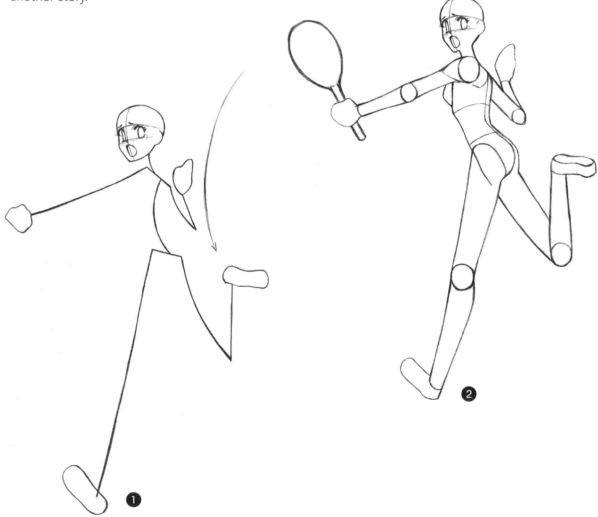

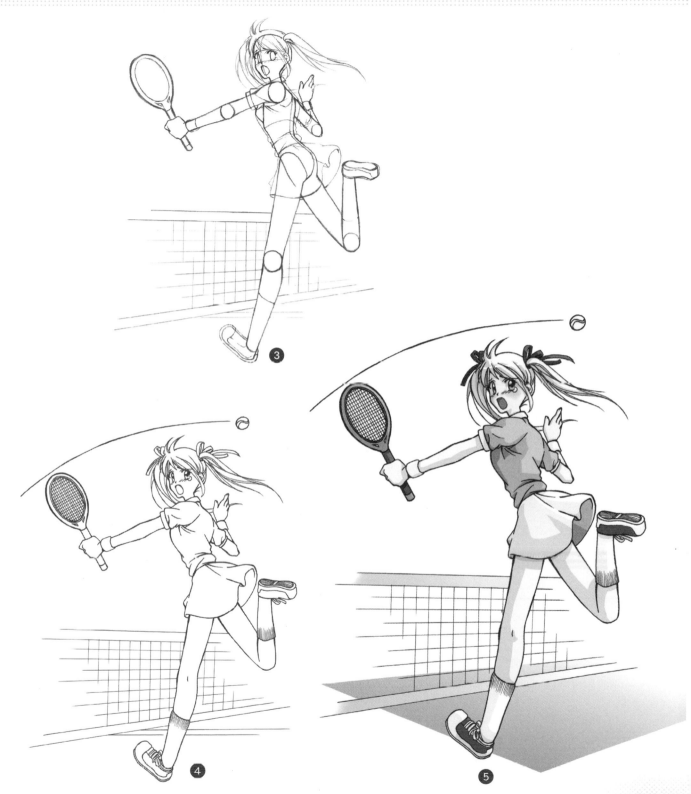

Baseball Boy

Young teens are often portrayed as sports enthusiasts. Sports competitions on the field or on the court are natural settings for dramatics.

A boy who cannot seem to muster what it takes to win can often dig down deep if he's doing it "for his girl." Grudges play out, and one-upmanship also occurs during the heat of battle. So a lot of good story elements come into play around the theme of sports.

Here we have a shoujo boy who's practicing with his team. He wears a hooded shirt under his jersey and regular pants instead of a complete uniform. It's a good look that shows he's on a school league, even if it's not game day.

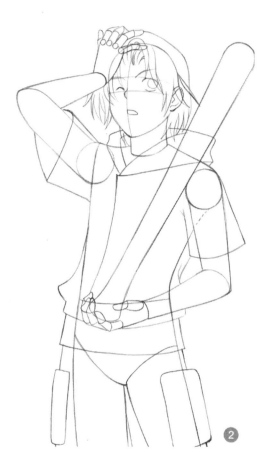

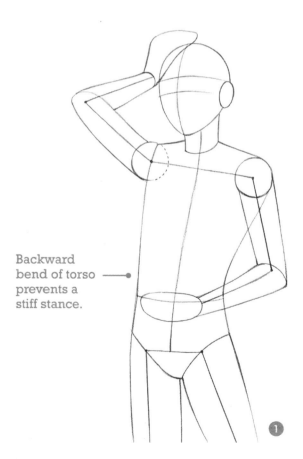

Backward bend of torso prevents a stiff stance.

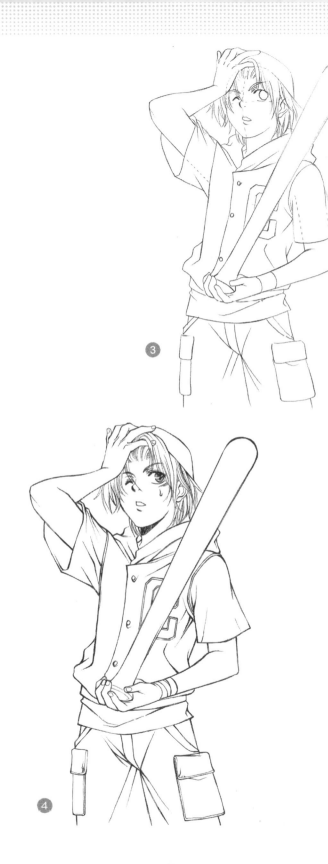

③

④

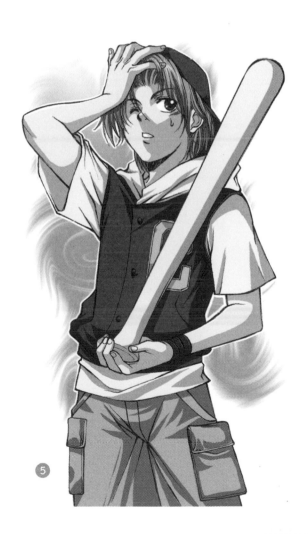

⑤

Magical Fairy

The magical shoujo girl is usually an ordinary schoolgirl who is magically transformed into a super-idealized fantasy figure with special abilities and talents—things she has only dreamed about. Once transformed, she appears amazingly glamorous in her new, heroic role. Her outfit is often a transformed, totally revamped version of a school uniform. She usually has a wand, a sword, a staff, or jewels and crystals through which she derives her powers.

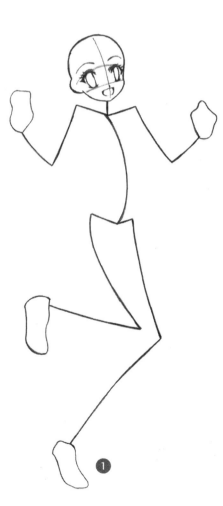

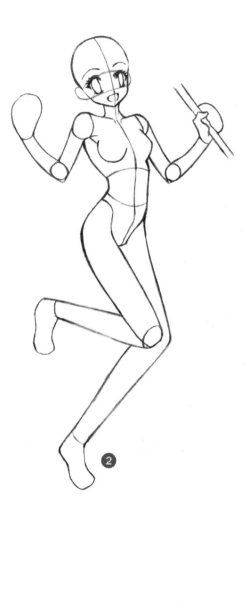

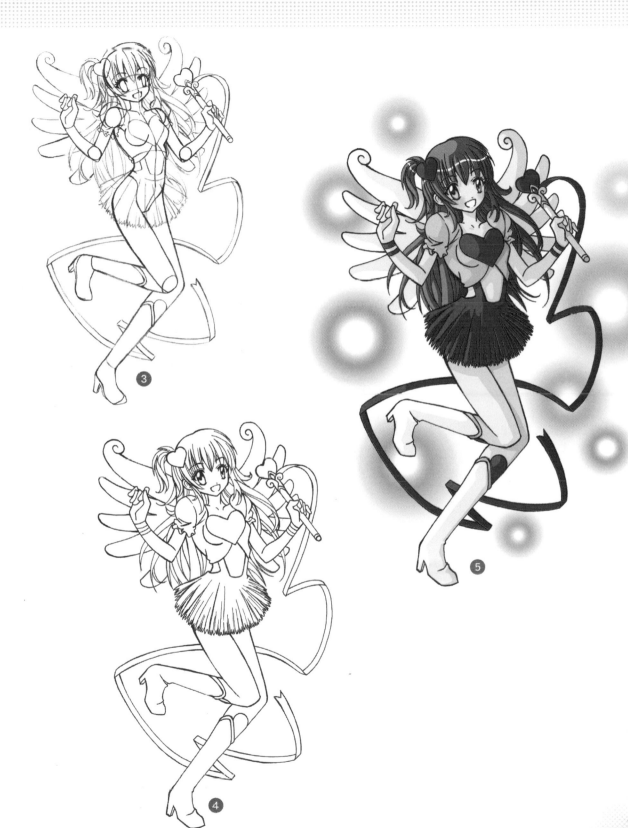

Honors Student

With his glasses and books, he's a scholar who also happens to be a handsome young kid. All the girls go to him for help with their homework—even if they already know the answers!

It's a subtle angle, but we, the readers, are looking down on the character from above. And we know that because we're also looking at the top of his head, the top of his shoulders, the top of his books, and the top of his shoes.

Take special notice that the shoulders are slightly wider than the feet. Due to the effects of perspective, things that are closer to us (the shoulders) look bigger than things farther away (the feet). To draw this in perspective, add wide shoulders, then taper the body down to small feet.

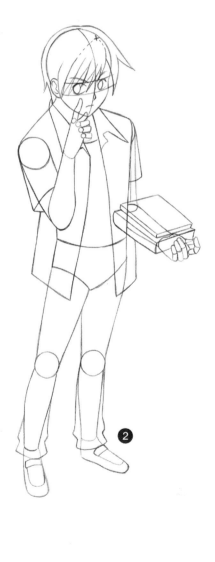

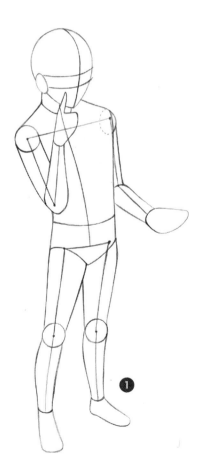

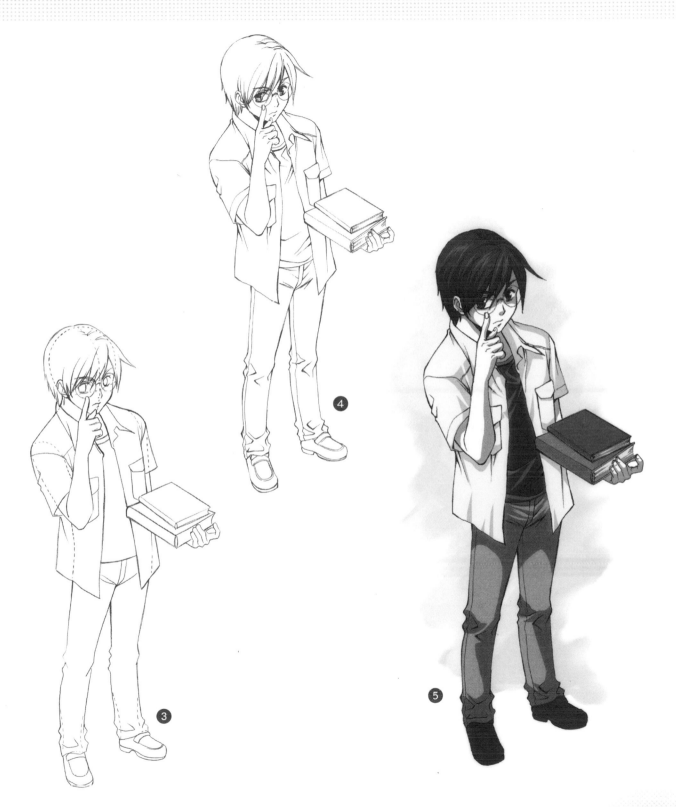

Holiday Girl

These ever-cheerful holiday characters are popular staples in shoujo. They're playful teens who dress up in a variety of fun costumes, from Santa's helper to ice-skaters. They are most often portrayed as having fun—with an exuberance that is contagious. In addition to appearing in graphic novels, they also serve as superb visuals for advertising pieces, promotions, logos, and greeting cards.

Note that the basic construction of the torso is created from three simple shapes.

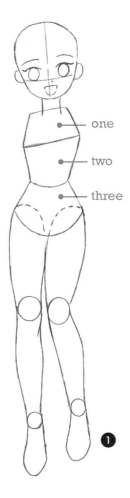

one

two

three

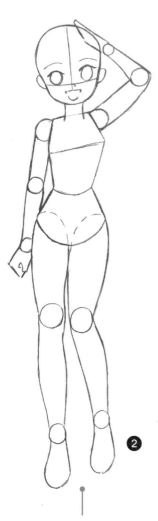

Vary the placement of the feet to show movement.

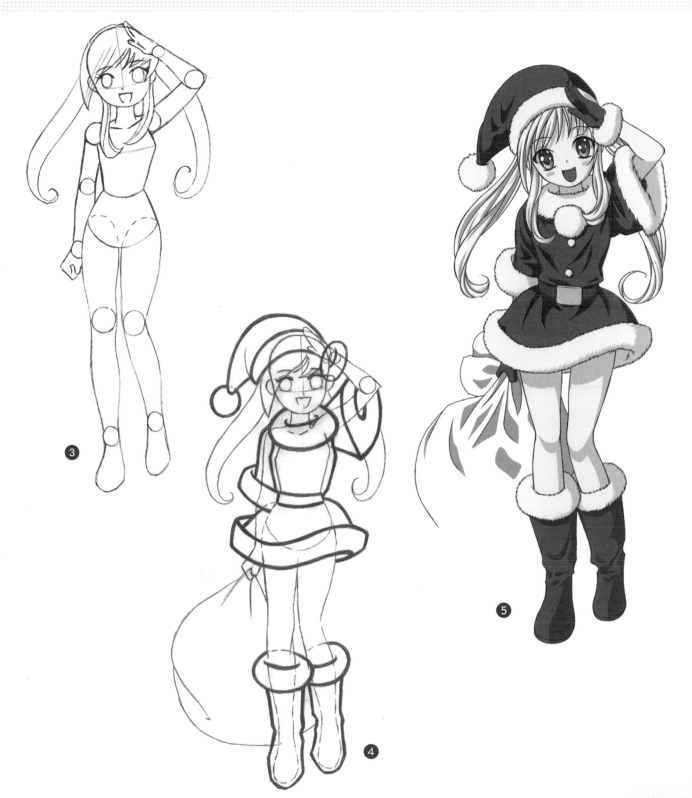

③

④

⑤

Kid Confident

Artists are always looking for fresh ways to draw things they've seen before, and new angles from which to draw them. Here is an inventive pose; it's unusual because the foot placement is uneven. And the body language, combined with that smile, gives the character an air of confidence. Although the torso leans back, the hips and the head remain straight and in place.

Props also add interest. Here, it's a ball, but you can use other props for this pose: a crate, tree stump, rock, backpack, or some stairs would all work.

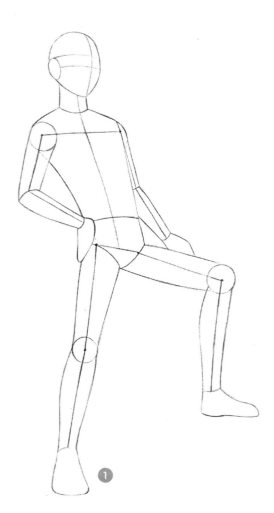

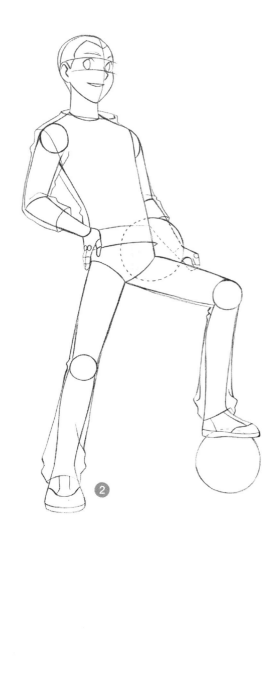

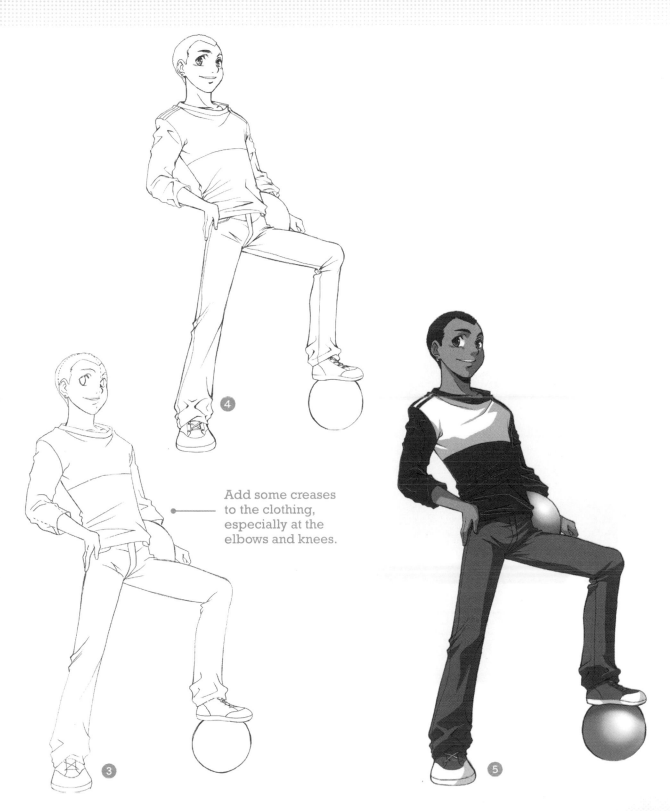

Add some creases to the clothing, especially at the elbows and knees.

Traditional Japanese Girl

Traditional Japanese outfits immediately signal to the reader that the story takes place in Japan. Characters who wear kimonos are often portrayed as modest and polite, which makes sense, because their clothing reflects their traditional values. The feminine grace of shoujo makes an excellent choice for this character type.

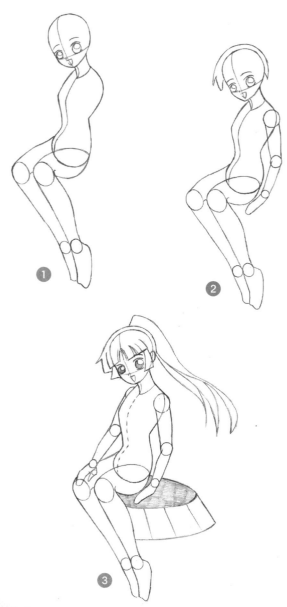

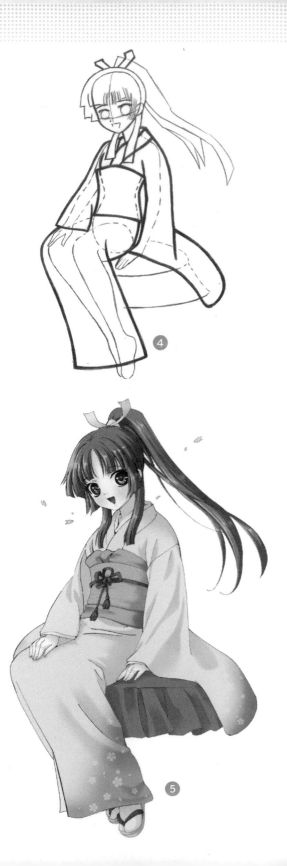

Teen Girl with Puppy

Eye contact is important, whether your two characters look at each other or not. One option besides mutual eye contact is to have one character look at the other, while that character looks at something else. Another is to have one character look at readers, engaging them and drawing them into the scene. Here we have only one character looking at the other; the girl looks at her pet, while the dog is busy doing his own thing—sniffing out that special treat.

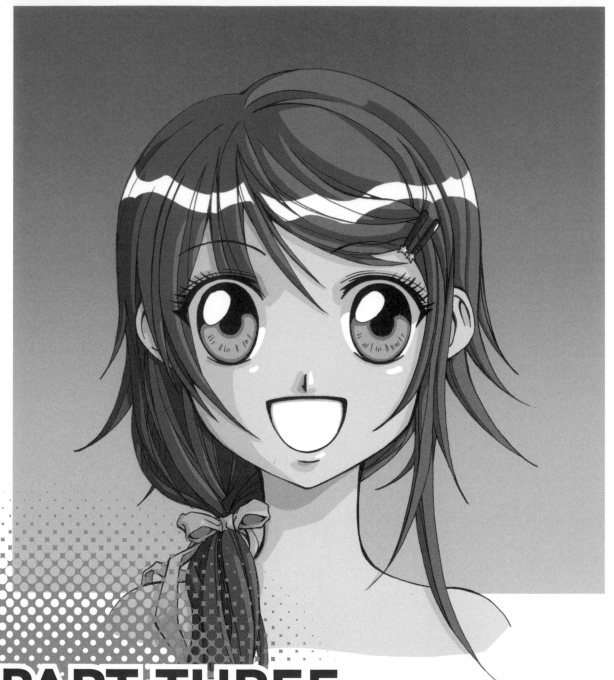

PART THREE
Let's Practice It

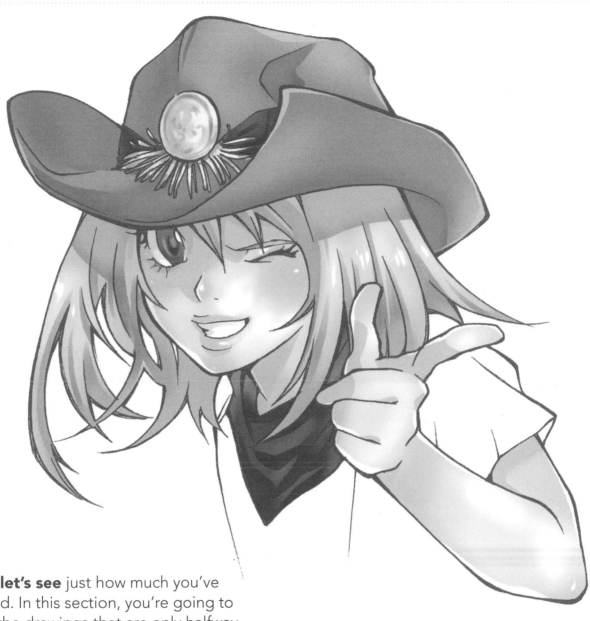

Now, let's see just how much you've learned. In this section, you're going to finish the drawings that are only halfway done; you get to add the rest—the eyes, hair, body, or the expression. This is a great way to practice your newly formed skills, and a chance to exercise your own creative license in drawing shoujo characters. I hope you've had as much fun as I have!

Draw in some shoujo-style hair on these girls.

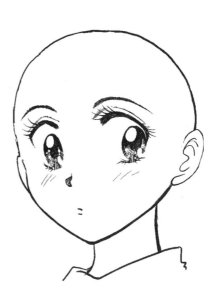

Give these boys some cool-looking hair.

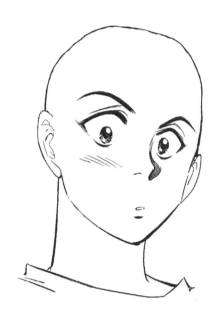

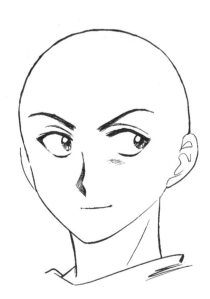

Fill in this girl's facial features.

Fill in this boy's facial features.

Give this girl an angry expression.

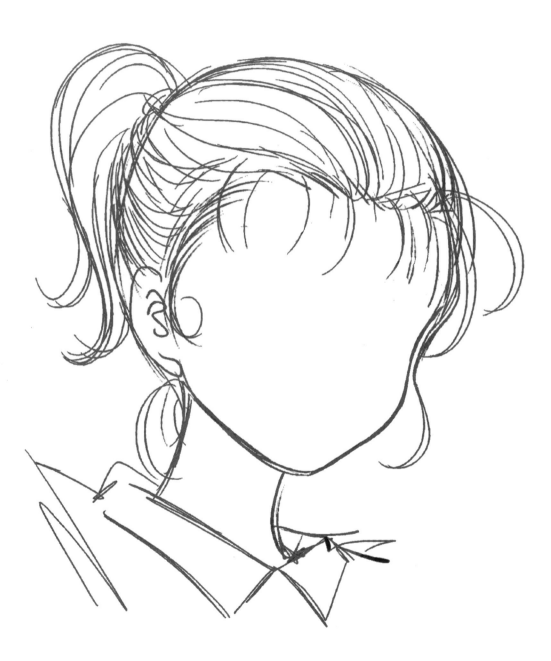

Draw an expression on this girl that displays happiness or joy.

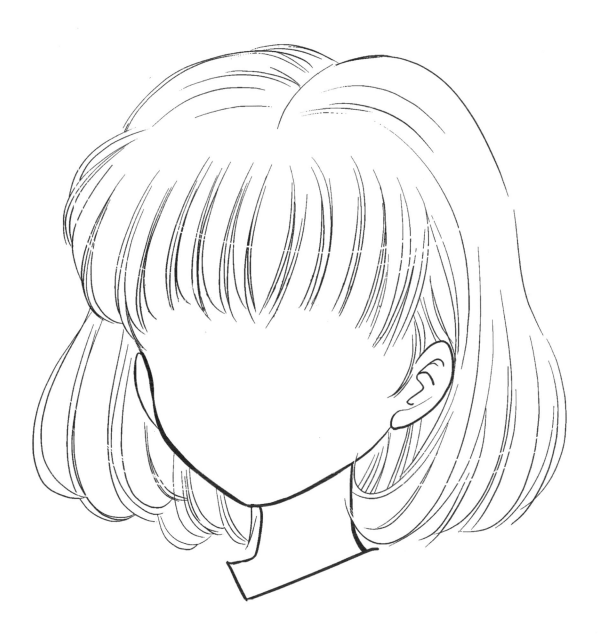

Finish the drawing by giving this girl a body.

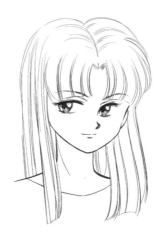

Try copying these eyes, and draw some of your own.

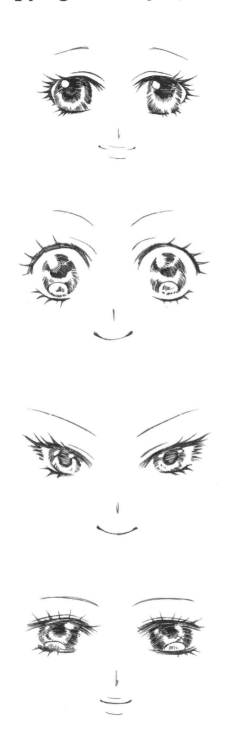

Also available in *Christopher Hart's Draw Manga Now!* series